The Meaning of Life

Other books by Bradley Trevor Greive

The Blue Day Book
Dear Mom
Looking for Mr. Right
The Blue Day Journal and Directory

The Meaning of Life

Bradley Trevor Greive

Andrews McMeel
Publishing

Kansas City

02 03 04 05 06 TWP 10 9 8 7 6 5 4 3

ISBN: 0-7407-2336-7

Library of Congress Control Number: 200109828

Book design by Holly Camerlinck

Attention: Schools and Businesses

Andrews McMeel books are available at quantity discounts with bulk purchase for educational, business, or sales promotional use. For information, please write to: Special Sales Department, Andrews McMeel Publishing, 4520 Main Street, Kansas City, Missouri 64111.

The Meaning of Life

Prologue

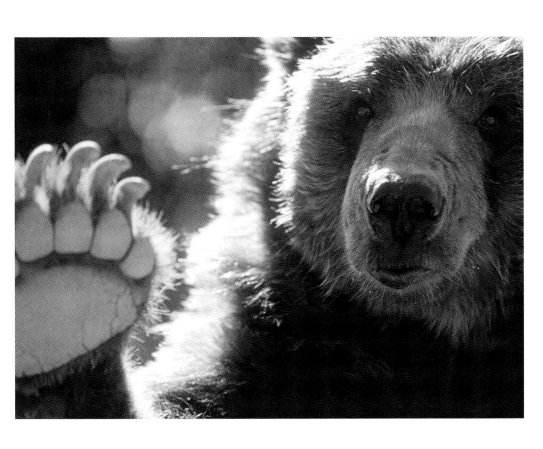

Halt! Whoa! Stop right there!
Before you read any further there's something
you really should know.

You may have opened this little book expecting it
to be filled with answers, but (surprise, surprise!)
it's actually a book about questions.

This may not be what you wanted to hear.

Most people don't like questions—they like answers.
And if they don't get easy answers straight away,
their eyes immediately start to glaze over.

Pretty soon they're off in a lovely daydream
about dancing cupcakes, singing turnips, and soaking
in a bathtub filled with warm vanilla custard.

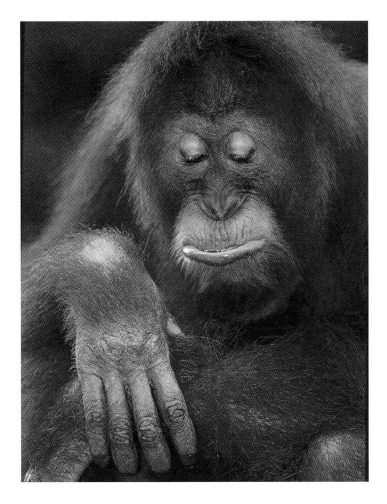

So, and this is important, if you feel like saying,
"Questions? Pffffffffff. Who needs them?"

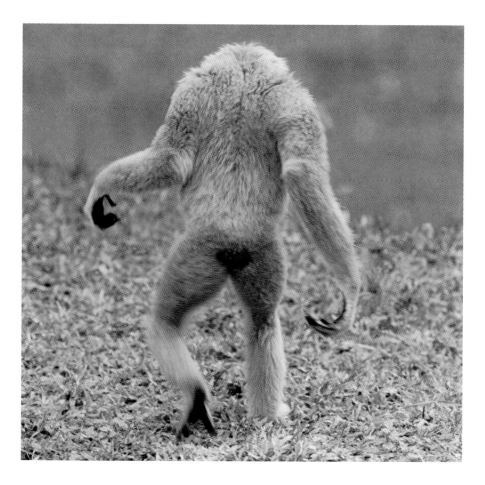

then this is your last chance to throw this book away and
wander off to watch reruns of *Gilligan's Island*.
I repeat, *this is your last chance*.

The Meaning of Life

No matter how you look at it, life is strange.

Very strange.

For example, it's an indisputable fact that we are all made of the precise same substance as the most intelligent, creative, magnificent life-forms in the entire universe.

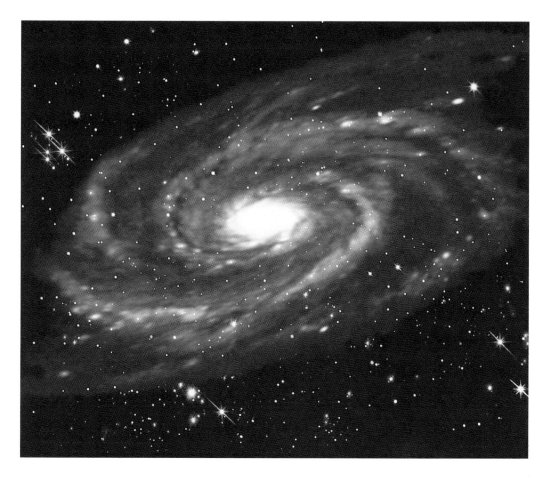

Furthermore, we are composed of the exact same atomic matter as the mightiest mountains on this planet and the brightest stars in the galaxy.

Of course, this is also true for potatoes, snails, and meatloaf—perhaps that's why there's so much about life that doesn't make a great deal of sense. 7

For starters, why are we so overly impressed by
and obsessed with objects and achievements
of immense scale,

when it is actually the tiny little things that,
when put together, make big things possible?

Why do we try to create our own little worlds
so we have the illusion of being completely in control
of our entire existence,

when we know with absolute certainty
that we are not?

Why do we go on and on about individuality
being the very essence of who we are,

and then accept a degrading level of conformity
in virtually every facet of our lives?

Why do children believe in fairies,
but "grown-ups" don't?

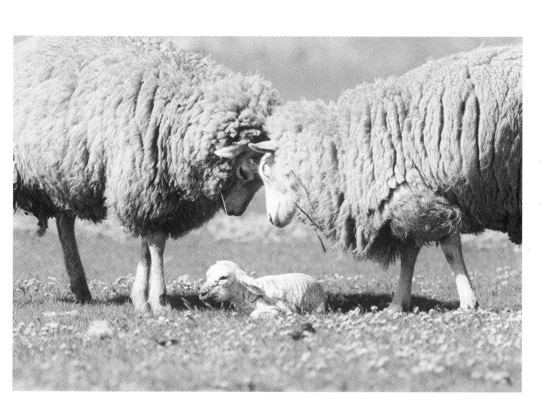

And why do we get so hung up on what we
don't agree on, when in fact it's our differences
that make life interesting?

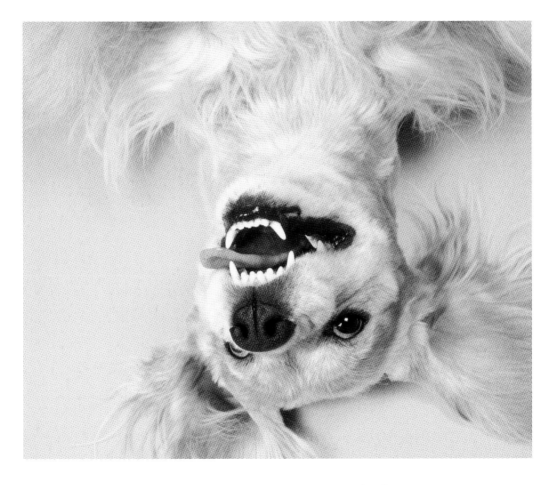

After all, half the world is upside down,
so there's absolutely no reason why we would
all agree on everything.

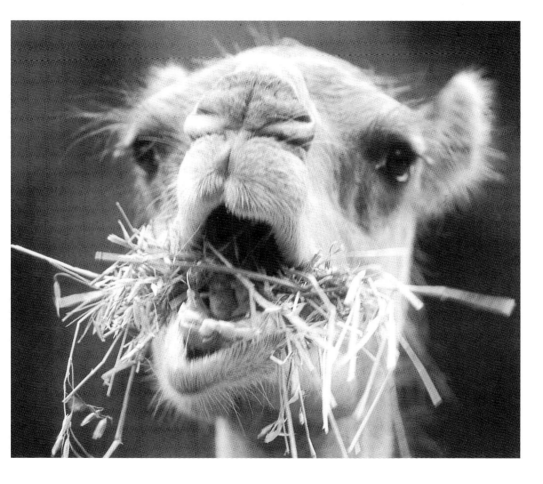

Even something as basic and profound as
"Don't chew with your mouth open" is not as
widely accepted as you might think.

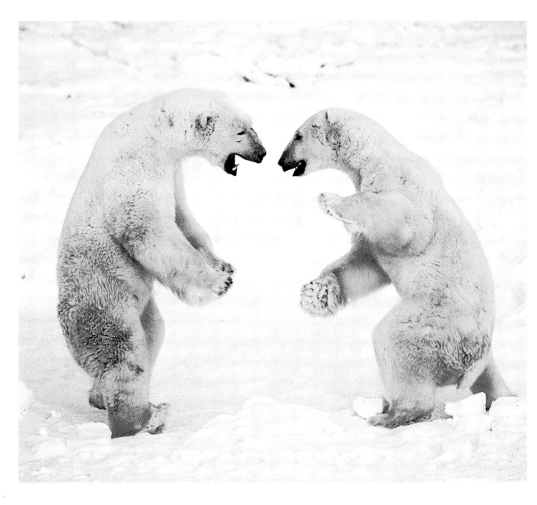

Why is it that when passions are inflamed
we choose to argue and fight,

when dancing the cha-cha is less injurious,
far more enjoyable, and equally effective
in resolving the tension?

20 And why do we feel drawn together as a species,

yet we steadily build up defensive barriers
around our innermost feelings and beliefs
so we can never be truly close to anyone?

Perhaps the confusion arises because life
is not always what it seems.

As a species, we are obsessed with
superficial appearance.

We all have filters on, so we mostly see only what we want to see. When you finally open your eyes, you may be shocked at the obscured way you have been viewing the world to suit your own little plans.

With those filters removed, you can take a closer look into yourself and ask objective questions about the universe and your place in it. In other words, investigate the meaning of life.

So what is life all about? Well, you often hear that "life is a
journey," but a journey to where, exactly?

Some people say that life is all about
acquiring knowledge. If that's true, then why
do smart people always dress so badly?

There are those who say that life has no purpose;
it just "is." Whoa, that's just so "deep!"

Then there are people who say that we're simply here
to have a family. After all, the desperate need
to replace ourselves is etched into the
genetic map of every living thing.

However, this means that our entire existence is driven
by our primitive sexual urges. Okay, sure, a long weekend
maybe, but our entire existence? I don't think so.

In fact, come a tiny bit closer and I'll let you in
on a little secret . . .

ALL THESE IDEAS SOUND
COMPLETELY STUPID!!!

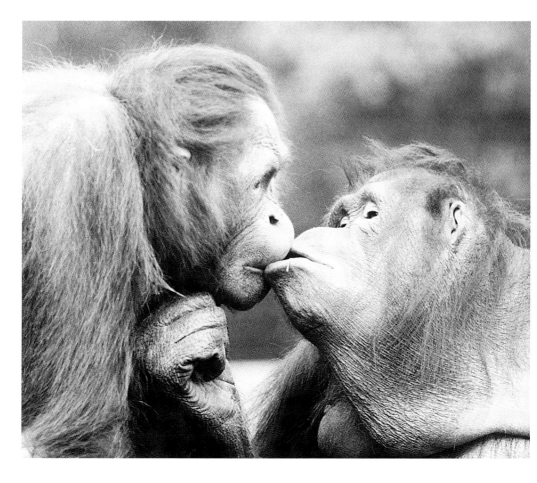

Of course, I'm not talking about romantic,
"kissy-kissy" love, although that is
pretty powerful stuff in itself.

It's well documented that a broken heart feels
far more painful than squeezing lemon juice
over a deep paper cut.

But the love I mean is the fire that burns inside
us all, the inner warmth that prevents our soul
from freezing in the winters of despair.
It's the love of life itself.

It's the voice that says "Celebrate life, be creative!"
It brings with it the passion and understanding
that some things in life are worth dying for,
but there is so much more worth living for.

It encourages us to greet each moment the same way
we greet an old friend at the airport, to embrace
opportunities to express ourselves in a way
that makes us feel glad we exist.

This love of life leads us to help others
simply because it feels great to contribute
to those around us.

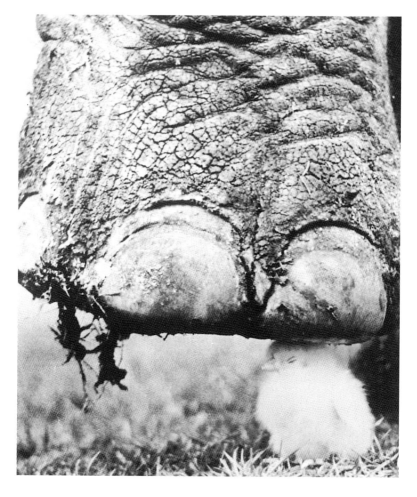

We all know how wonderful it feels to be a rock for our
family and friends (of course, there is a limit).

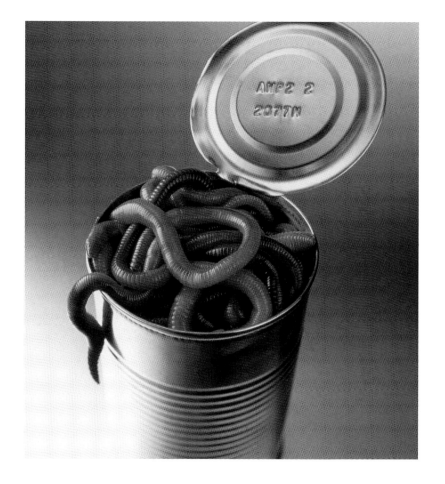

But as good as it sounds, and as much as
"you're here to live the life you love" rings true,
it still brings up a whole pile of sticky questions. 41

Specifically: Why exactly are *you* here?
What is it that *you* truly love?

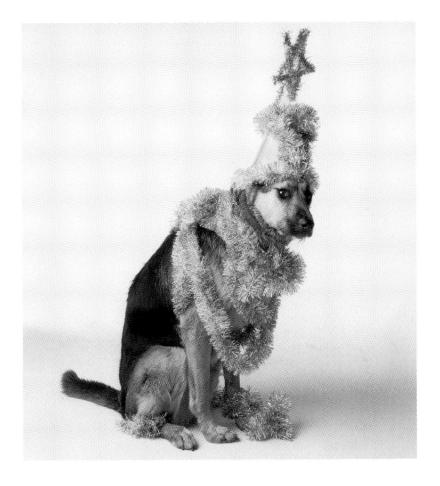

People who don't ask themselves these questions
invariably go through life wondering why
it isn't a lot more fun.

They often feel they've been left behind,

or they can't quite put it into words, but they sense
that something just smells a little funny.

The truth is that often we're so focused on what we are
doing that we lose sight of where we are going.

But what are we actually doing?
The modern world is filled with questionable distractions,
deadlines, and priorities.

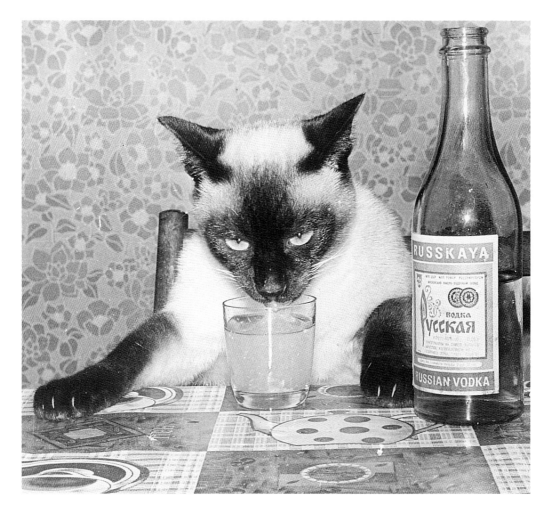

Day and night blur into one.

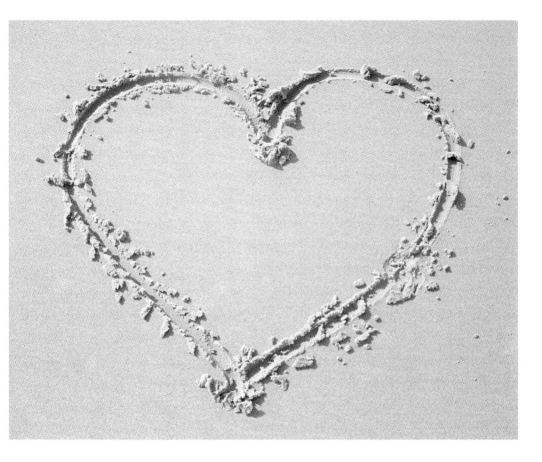

The only theme that resonates throughout the numerous popular life theories is love. Love, in all its fragile forms, is the one powerful, enduring force that brings real meaning to our everyday lives.

33

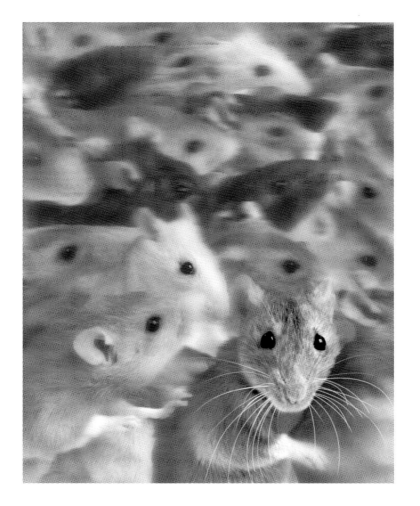

We get caught up in an avalanche of fears and desires
that propel us into a race we can't possibly win.

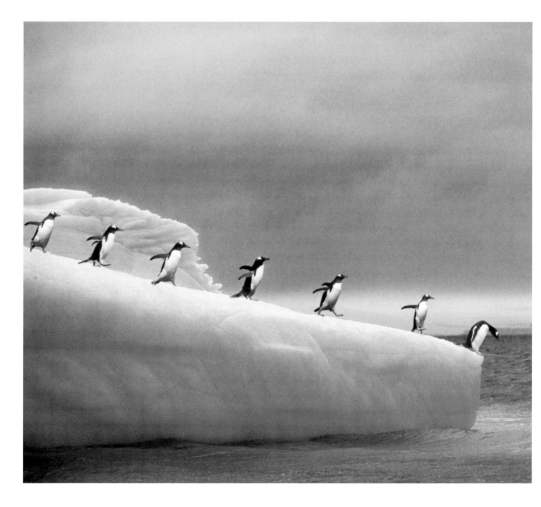

So we rush, rush, rush to get to a certain
ideal point in our life, and then what?

It's just like when you drive all the way
to the store, get out of the car, and then
can't remember what you came for.

So many of us start off dreaming about a
wonderful life that is wild and free,

but that's usually a long way
from where we actually end up.

Sadly, we often discover this fact right at the end,
when it's too late. You can't start all over again.

And let me tell you, there are some awfully bad feelings
in this world. Like "bubbles in the bath" guilt,

"pungent foot odor in the shoe store" embarrassment,

and "I can't believe I did that
on the first date" anxiety.

But of all the awful feelings that make you feel
sick to your stomach, nothing feels half as bad as
knowing you had a chance to do what you truly love,
and you didn't take it.

So what is your life's passion? What were you put
on this earth to do? The answer to these
questions will unlock the great mystery of life;
it's as big as they come.

Here are a few hints that may help you
get on the right track:

First, no one is going to tell you about it. It's like walking
around all day with a sign on your back that says "Kick
me." You must discover it for yourself.

It's also highly unlikely that one day you'll
suddenly be bathed in bright light and your
life's purpose will be laid out in a divine vision,

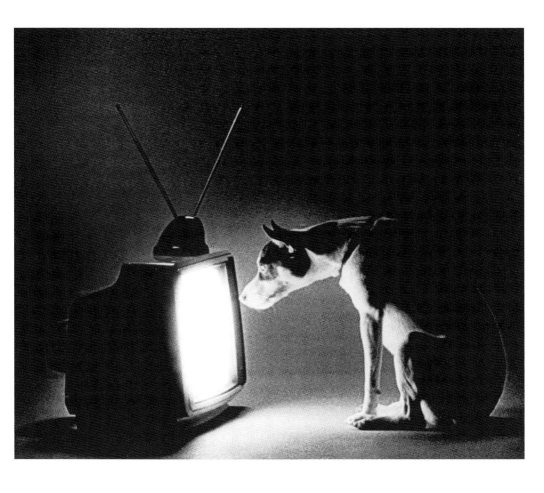

and it's guaranteed that you won't find it
on television.

Yes, it's remotely possible that one day the blood will rush to your brain and enable you to work it all out without too much bother,

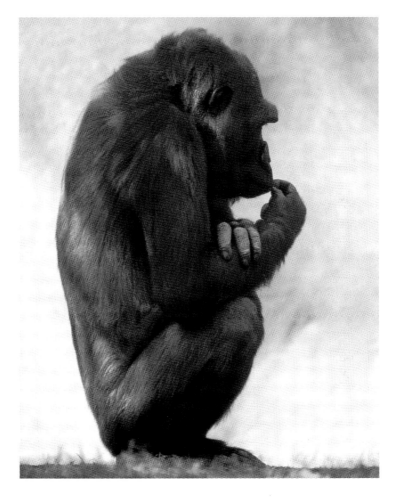

but the best way is to spend some quality time alone,
asking yourself the tough questions.

This exercise is not that hard, and it's all about
being honest. It's as easy as "Raise your hand
if you feel you could get more out of life."

It's also about getting to the essence of what really matters. Never mind *who* moved your cheese—ask yourself *why* you were looking for cheese in the first place!

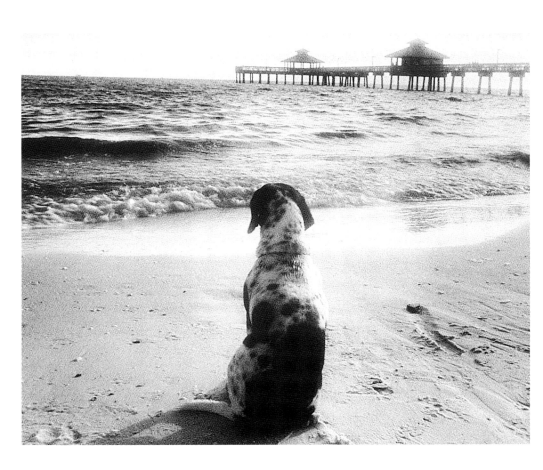

For some people this will simply be a case of seeking out
the moments in their life that are beautiful and true
and then building a plan around them.

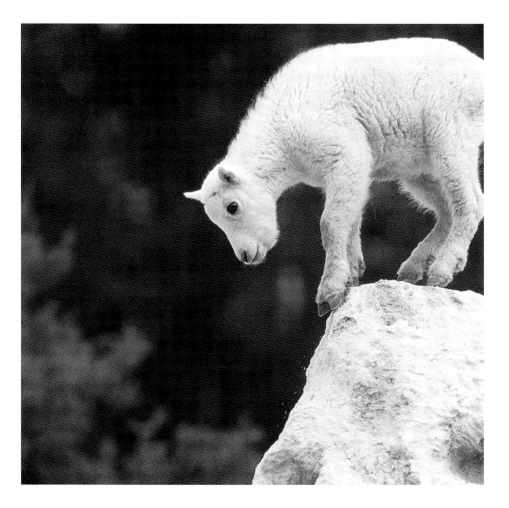

For others it may feel as if they are
staring into an abyss.

In extreme cases, such intense introspection
may cause the brain to swell to dangerous dimensions.
Trust me, it's worth the risk.

If you ask the big questions and listen carefully to your
heart, you will eventually hear destiny call you.

A little voice—call it your conscience, your inner self, or
your internal mother-in-law—will always
tell you the truth if you are prepared to hear it.

At first you may only become aware
of how your life has been stuck in a rut.
(Hey, join the club!)

73

Then you may realize what you really want,
but you just can't quite make it happen.

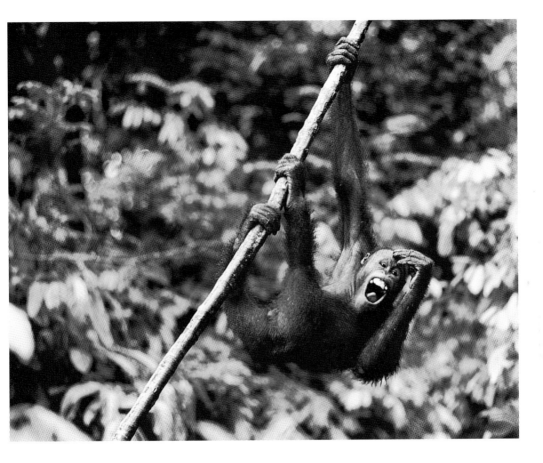

Pretty soon, though, it will hit you right between
the eyes. Just like when you're halfway to the
beach and suddenly remember that you
left the iron on at home.

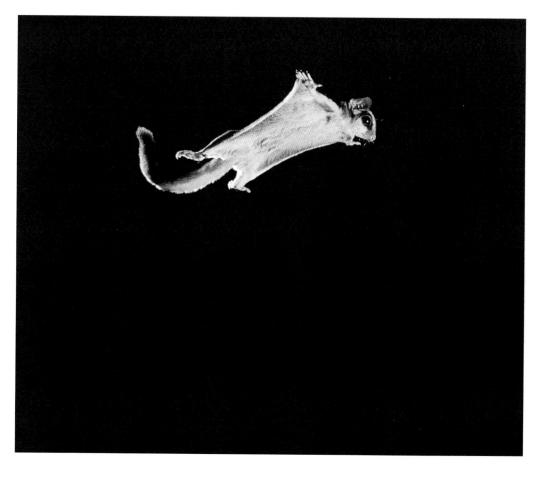

And when you know, or even suspect you know, what you should be doing with your life, then do it! Take a wild leap in the dark if you have to,

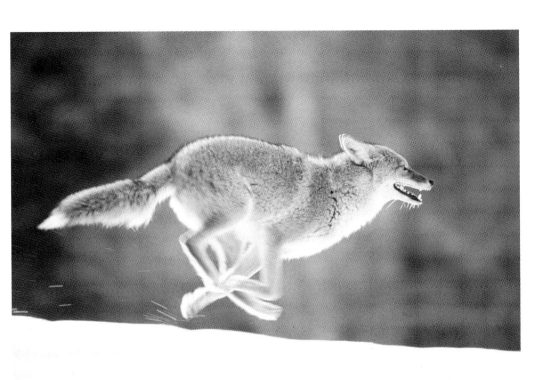

then hit the ground running
because you don't have a second to lose.

In spite of our feelings of invincibility
and immortality,

our existence is far more tenuous
than we might think.

Place your hand over your chest and feel your heartbeat.
That is actually your life clock ticking, counting down
the moments you have left. One day it will stop.
That is 100 percent guaranteed, and there's
absolutely nothing you can do about it.

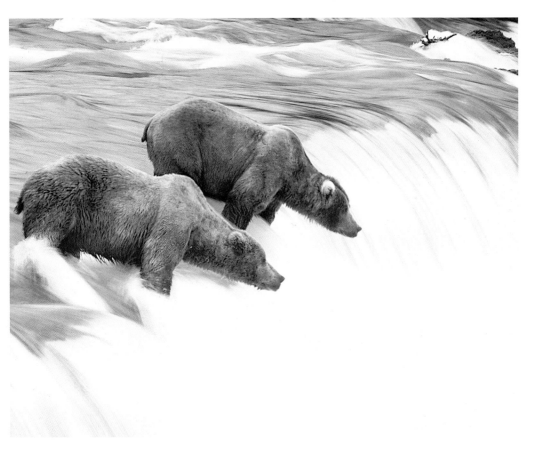

So you can't afford to throw away a single
precious second. Go after your dreams with
energy and passion, or you may as well stand back and
watch them wash down the drain.

If you waste your life sitting on the fence, you'll end up
going nowhere in the brief time you have left.
(And then, of course, there's a dangerous risk of
splinters in delicate regions.)

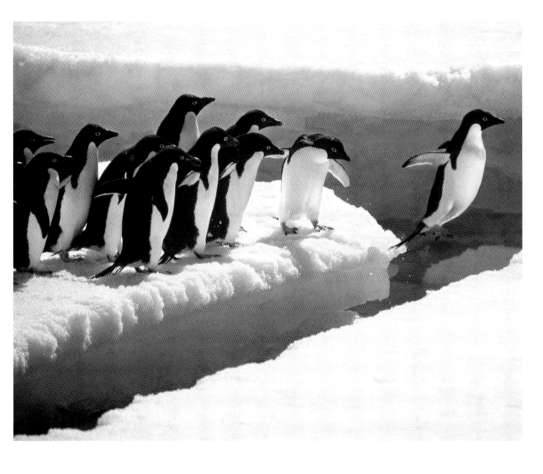

As they say, "You can't cross a chasm in
two small leaps." It takes courage and commitment
to live your dreams.

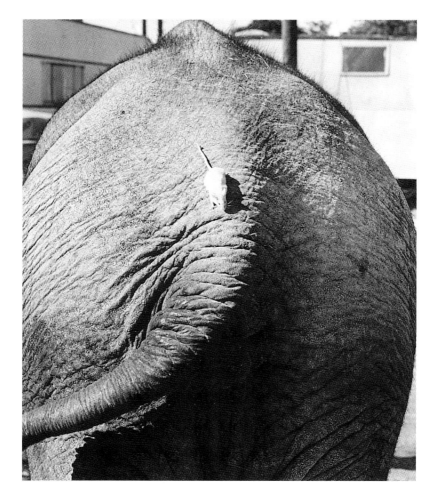

(Of course, one needs to remember where
courage ends and stupidity begins.)

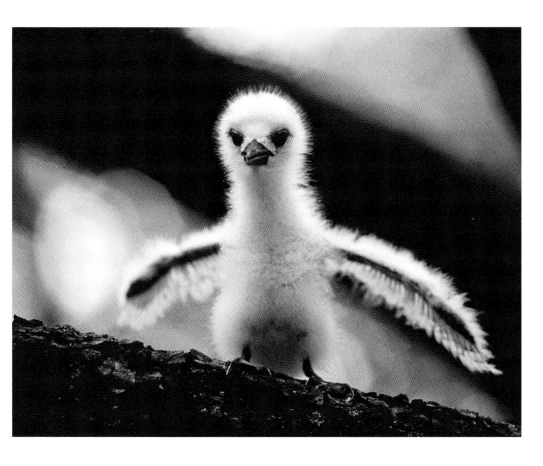

The truth is, we are all born with potential greatness
and blessed with numerous opportunities
to soar to dizzying new heights.

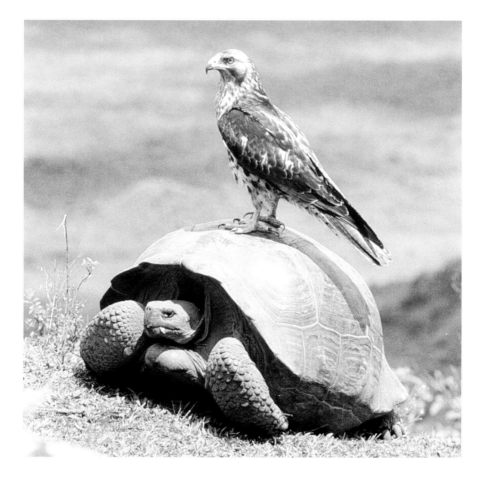

But sadly, many of us are too lazy, too concerned about
what others might think, or too afraid of change to ever
stretch our wings and realize our tremendous talents.

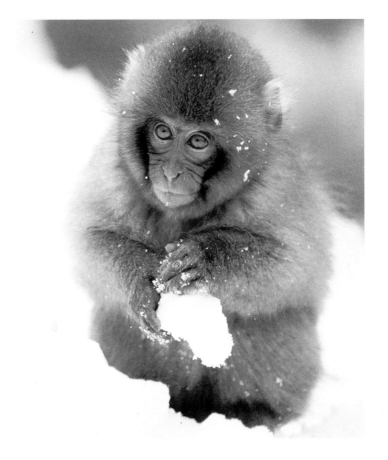

It's so important that you just do your
own thing—whatever makes you truly happy—
and do it as best you can. It doesn't matter
whether your "thing" is making snowballs,

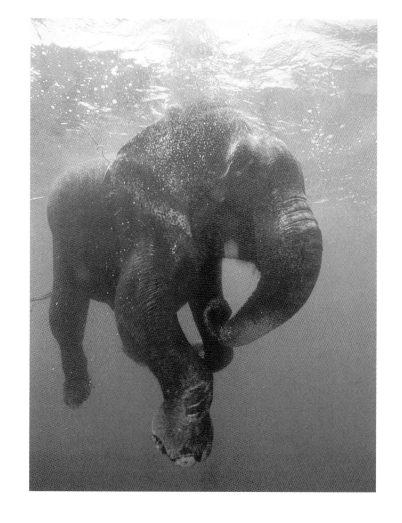

holding your breath underwater,

hog calling,

or wielding a hair-dryer with dramatic effect.
The only thing that matters is that you feel great
about what you're doing.

Keep in mind that whatever you do,
mistakes are part of life. So don't waste time
kicking yourself for the past.

Don't stall or stress over whether you're
doing the right thing. You'll always know
the answer in your heart.

Rather than be discouraged, always remember
that rejection and resistance are almost guaranteed when
you are doing something very important and very special. 93

When you set out to live your dreams, lots of people
(including those who love you the most)
will try to hold you back.

In this world there are many miserable pessimists who have given up their dreams and will tell you, "You're wasting your time—you'll never make it."

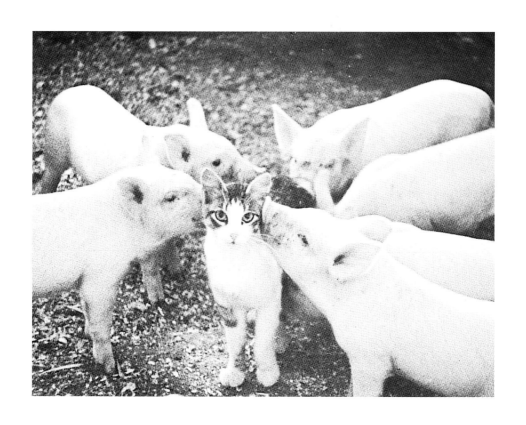

You may well be surrounded by people who secretly want
you to achieve less or even fail completely just so they
don't look bad. "Forget about it," they'll say. "It's not worth
it and it's not right for you anyway."

So it's important to understand that following
your own path is incredibly rewarding,
but it's definitely not easy.

Like everyone else, you will have some days
that are better than others.

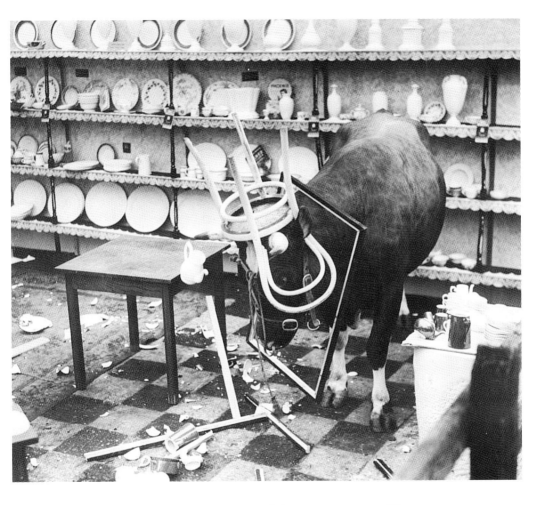

Occasionally, everything may seem like
a total disaster area.

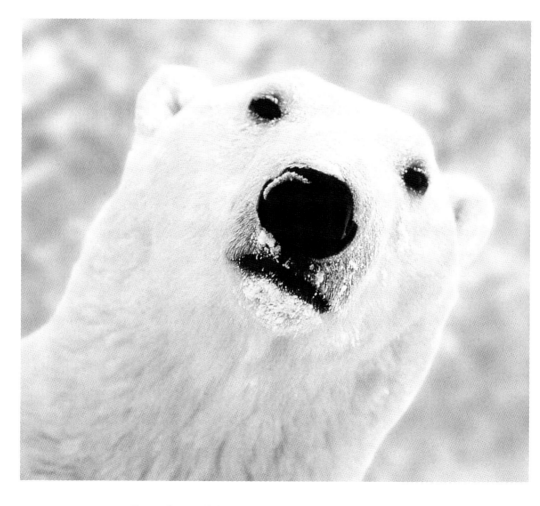

People will look at you strangely when
you tell them what you are trying to achieve,

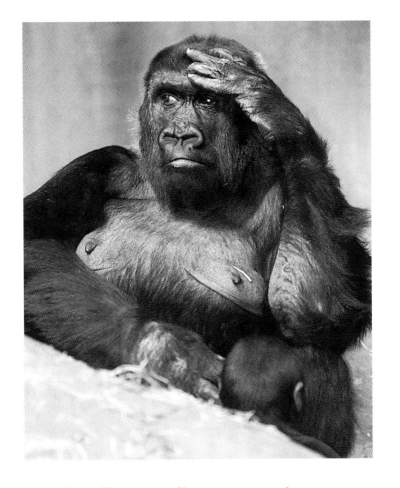

and you'll start to listen to your detractors
and doubt yourself. "Why, oh why, didn't I keep
my job selling hot dogs?"

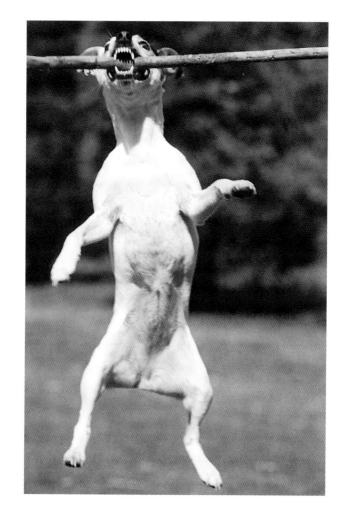

But whatever happens, *just hang on!*

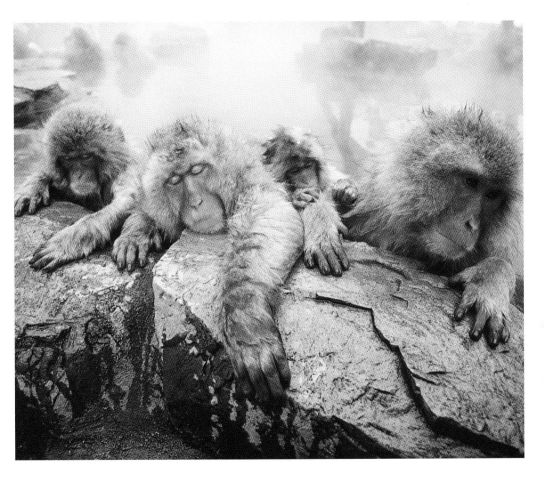

Remember that everybody struggles at times. It's
incredibly draining to live through the day doing
something you really don't enjoy or even care about. 103

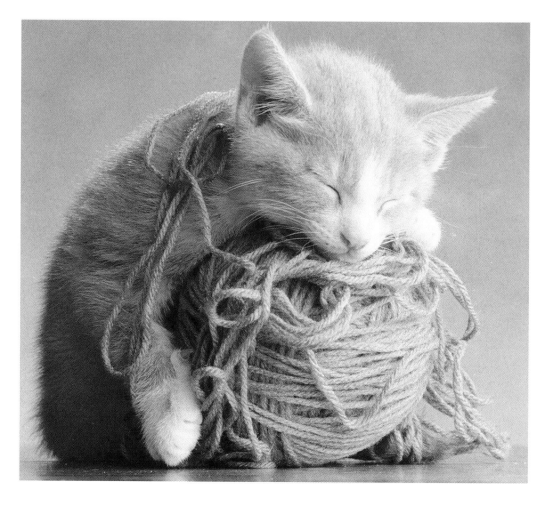

But if you follow your dreams, at least you will exhaust
yourself doing what you love most.

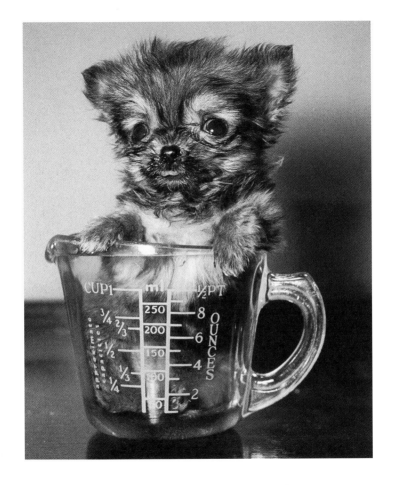

Now, you may not think that this will measure up
to much in the global scheme of things.
But believe me, it does.

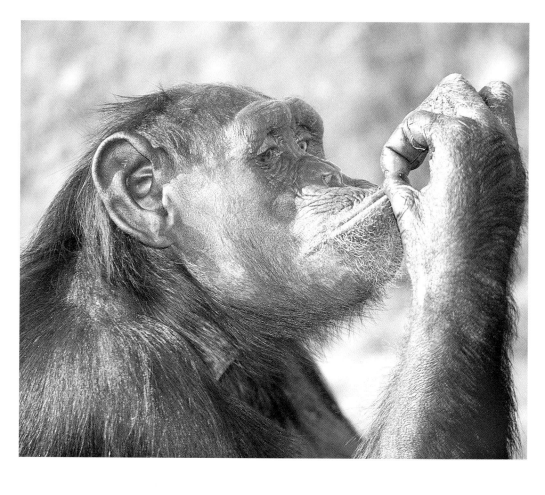

When you get the most out of your life,
savoring every last drop,

it will transform everything about you
from ordinary to extraordinary.

When you do what you love, you can pull back
the bed sheets every morning feeling excited
about beginning another day,

and you'll be filled with a heartfelt joy
that is highly contagious.

Just like when you start laughing out loud,

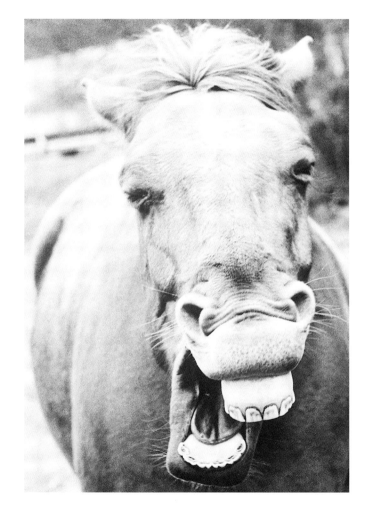

and you make someone else start laughing,

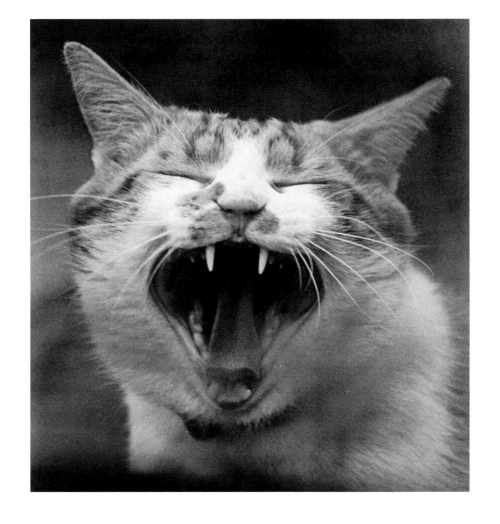

and then someone else,

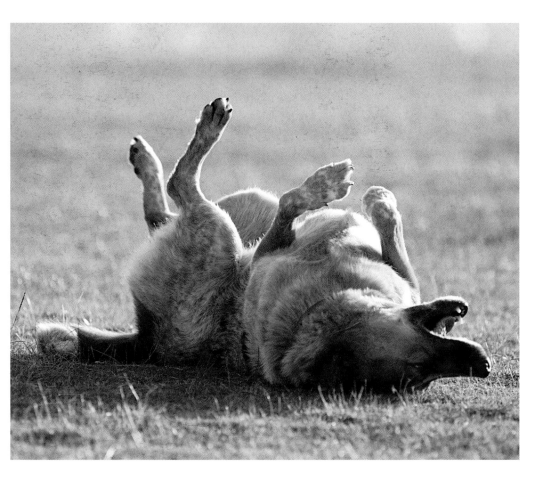

until you are all laughing so hard that your eyes water,
you get terrible stomach cramps, it's hard to breathe,
and you can't even stand up.

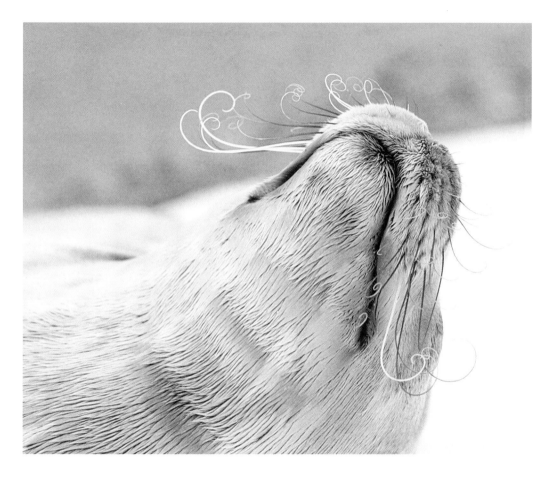

But best of all, by doing the things that make your
whiskers curl up with delight (assuming, of course, that
you actually have whiskers),

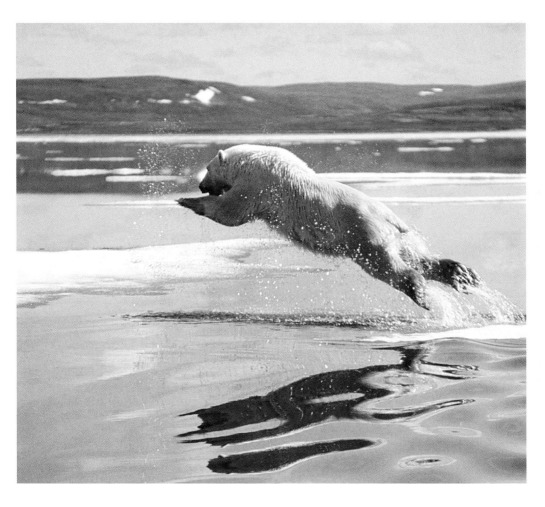

you will inspire someone else
to go after their dreams,

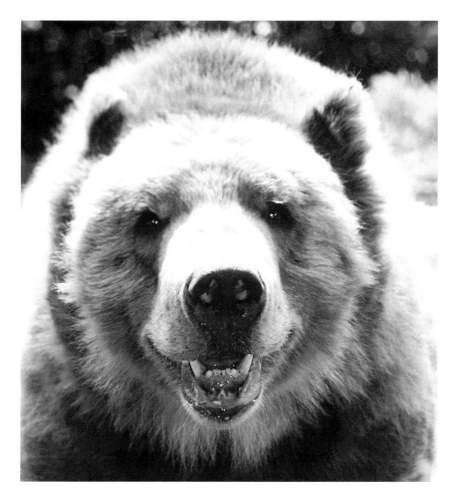

and that, my friend,
is how you change the world!

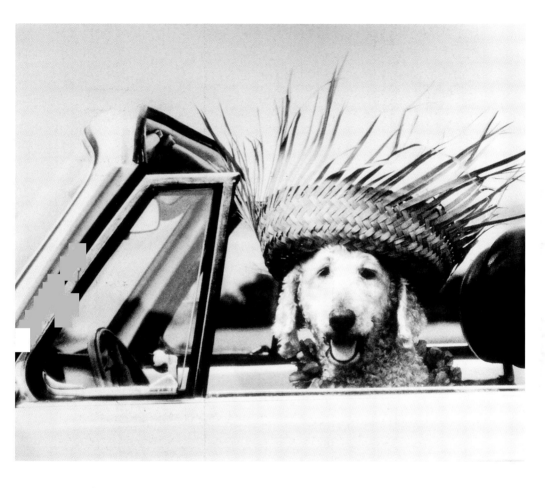

You know what? Even if you make big mistakes, if you're
wrong about almost everything, you'll still enjoy an
amazing, fun-filled life adventure,

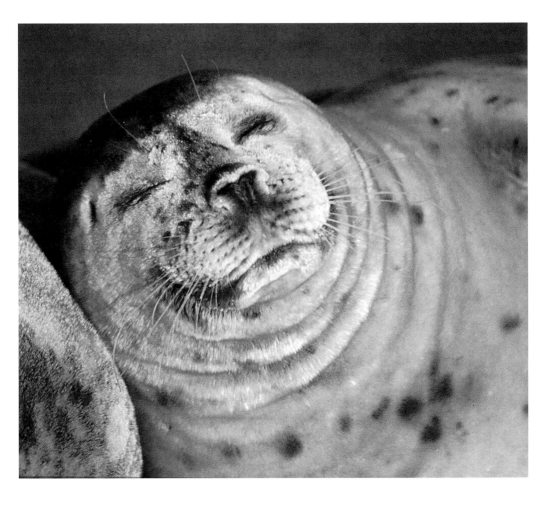

you will go to sleep at night knowing you
gave your all and made a difference,

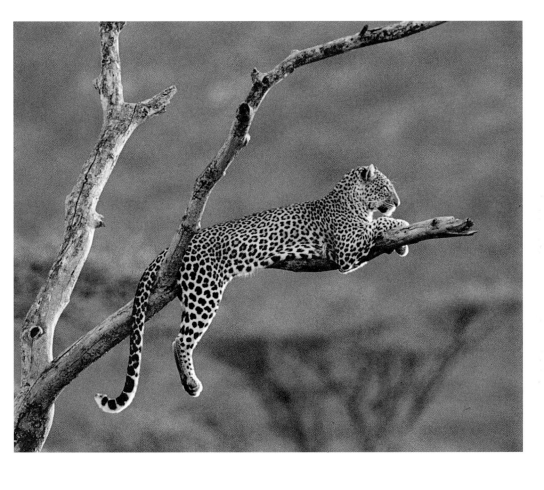

and wake up each day looking forward to a future that is
as beautiful and exciting as you can imagine.

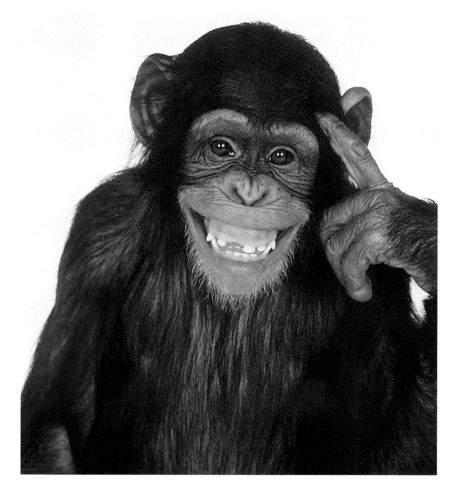

You know something else? If you just listen
to your heart and use your head,

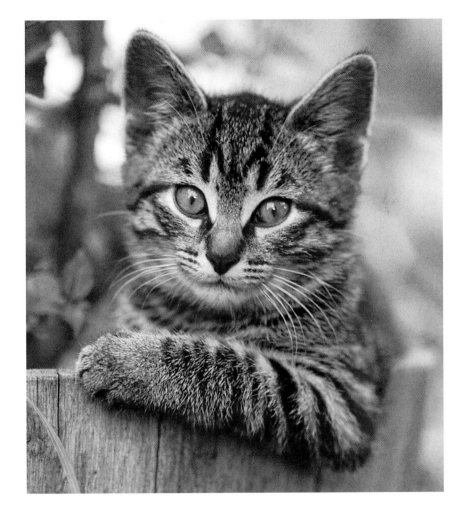

you'll never be wrong.

Photographs are used with permission from the following sources:

GETTY IMAGES (Sydney)
www.gettyone.com
Pages ix, x, xiii, xiv, xv, 3, 9, 16, 19, 20, 23, 28, 30, 32, 33,
35, 36, 37, 41, 46, 49, 50, 55, 62, 63, 65, 67, 69, 70, 73,
79, 83, 88, 97, 100, 104, 107, 108, 112, 114, 117, 118

WILDLIGHT PHOTO AGENCY (Sydney)
www.wildlight.com.au
Page 113

STOCK PHOTOS (Sydney)
www.stockphotos.com.au
Pages 4, 5, 6, 8, 13, 18, 29, 45, 53, 56, 71, 77, 101

MASTERFILE (Sydney)
www.masterfile.com
Pages 31, 43, 53, 58, 61

AUSTRAL INTERNATIONAL (Sydney)
www.australphoto.com.au
Pages 10, 21, 27, 82, 92, 102

PAVEL GERMAN WILDLIFE IMAGES (Sydney)
www.australiannature.com
Pages 64, 91, 106

ALEXANDER CRAIG (Sydney)
alexcraig@iprimus.com.au
Page 44

RICK STEVENS / *Sydney Morning Herald*
www.smh.com.au
Page 17

AUSCAPE INTERNATIONAL
www.auscape.com.au
Pages xi, 14, 57, 75, 76, 80, 85, 86, 87, 89, 90, 93,
94, 98, 103, 110, 115, 119

PHOTO LIBRARY.COM (Sydney)
www.photolibrary.com
Pages xii, 7, 11, 12, 24, 25, 34, 38, 39, 40, 42, 47, 48, 51, 59,
60, 66, 68, 72, 78, 84, 95, 96, 109, 111, 116

AUSTRALIAN PICTURE LIBRARY (Sydney)
www.australianpicturelibrary.com.au
Pages 15, 22, 26, 52, 54, 74, 81, 99, 105, 120, 121

Acknowledgments

Once again I owe heartfelt thanks to Christine Schillig and her all-star team at Andrews McMeel, the incomparable Jane Palfreyman from Random House (Australia), and my own long-suffering legion at BTG Studios for making this svelte volume possible.

As always the photographers, and the blessed libraries who represent them, are the carrier pigeons of truth and beauty, and I thank them for allowing me to piggyback on their immeasurable talent.

It would be foolish to assume that I could have achieved anything without Albert J. Zuckerman, a literary agent who has provided the vital spark to ignite many careers more luminous than my own. But who could have thought that a man who once smuggled truffles into the Eastern Bloc to pay his way through college would figure so prominently in my life? Nevertheless this is so and, just as in 1938 when he toured sub-Saharan Africa as a circus conjurer along with a double-jointed ferret named Ferdinand the Flexible to raise the initial capital required to start Writers House New York, it is his unbridled creativity and ferocious tenacity that has put me on the map.

THE Taronga
FOUNDATION

Inspiring our community to create a better future for wildlife and our children

Bradley Trevor Greive loves animals and proudly supports the Taronga Foundation. To find out how you too can easily make a difference by becoming a Zoo Parent or by making a donation towards vitally important research and breeding programmes, visit the Taronga Foundation website: www.tarongafoundation.com